EMIL NOLDE

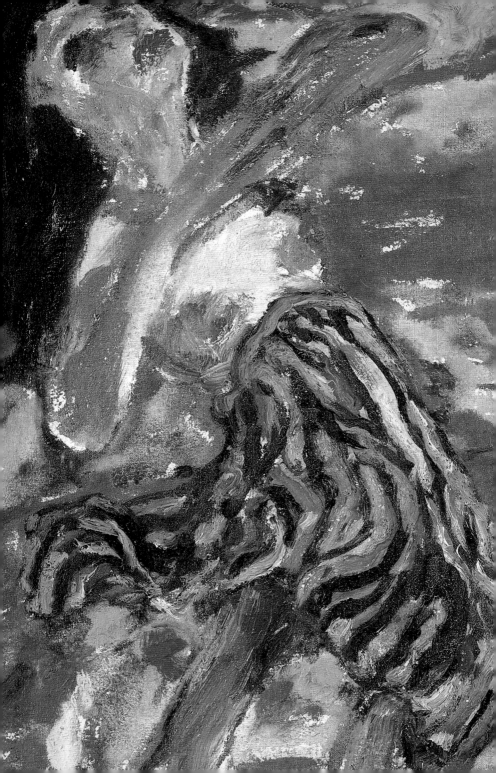

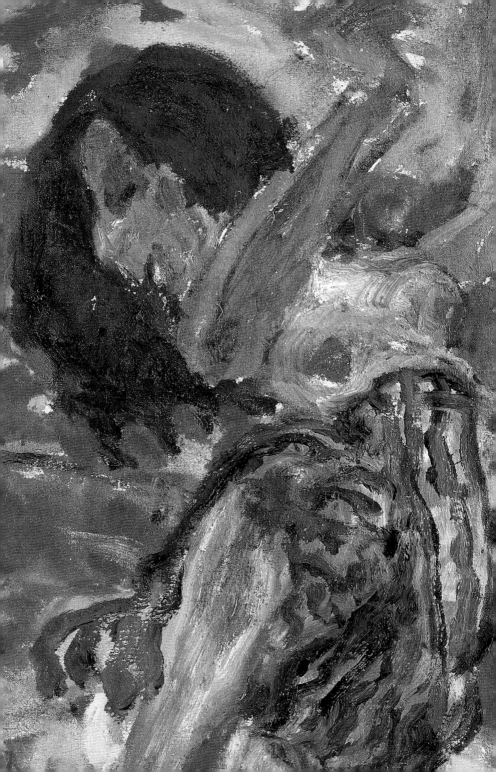

EMIL
NOLDE

WITH ESSAYS BY
Christian Ring and
Hans-Joachim Throl

HIRMER

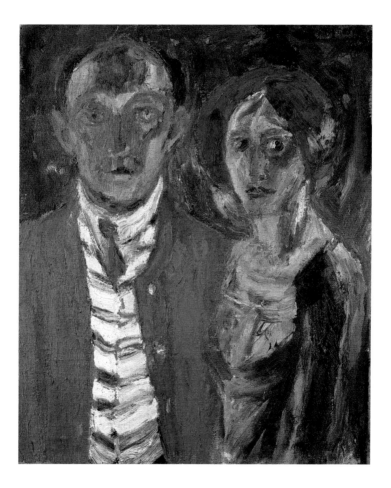

EMIL NOLDE

A. and E. Nolde, 1916, oil on canvas, Nolde Stiftung Seebüll

CONTENTS

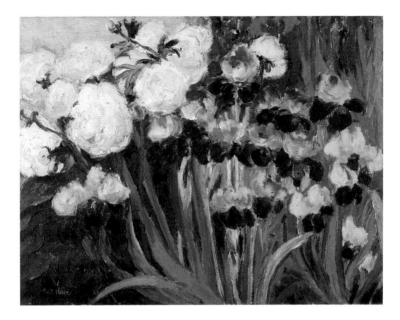

1 *Peonies and Irises*, 1936, oil on canvas, Nolde Stiftung Seebüll

"ART ITSELF IS MY LANGUAGE"

Christian Ring

The great colour wizard Emil Nolde is considered a maverick among the artists of Expressionism. His art was not, however, developed in isolation; it can be seen in the context of the breakthrough of the avant-garde in Germany at the beginning of the twentieth century. From his beginning as an artist, he found colour to be his proper means of expression. Nolde's engagement with nature began with his first pictures of flowers and gardens; in them he developed his concept of "the powerful effect and reliability of colour when applied spontaneously."[1] He then transfered this concept to all his other types of pictures and artistic techniques: figures, landscapes, seascapes, 'Bible and legend pictures,' scenes of Berlin's big-city nightlife, and freely invented compositions both fantastic and grotesque. With his extremely extensive and varied œuvre of a consistently high order he made a decisive contribution to the development of modern art.

EARLY WORK – "THE PENCHANT FOR PAINTING WAS THERE FROM THE START"

Even as a child, the farmer's son Emil Nolde felt a strong affinity for art. In his first attempts at painting he made do with elderberry and beetroot juice until a box of paints was given him for Christmas. He wanted to

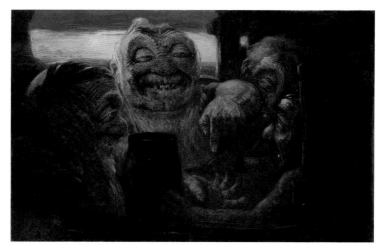

2 *Mountain Giants*, 1895/96, oil on canvas, Nolde Stiftung Seebüll

study painting, but his traditionally minded parents forbade it. As a compromise he trained in wood carving in Flensburg. After working as a carver and designer in Munich, Karlsruhe, and Berlin, he became a teacher of mechanical drawing in St. Gallen in 1892, where he also offered instruction in landscape drawing. He produced drawings of Alpine farmers, watercolour views of St. Gallen, and nearby landscapes. A small, postcard-size watercolour from 1895, with a fiery red sunrise developed solely out of colour, would suggest the direction of his later art. Without any training in the use of oil pigments, he created his first oil painting in 1895/96, already in large format, titled *Mountain Giants* (*Bergriesen*) (2); Nolde worked on it for almost two years. He had a series of grotesquely humorous depictions of Alpine peaks in the guise of figures from sagas and fairy tales printed up in large quantities as postcards, which quickly sold out. This financial success made it possible for him to resign his post in St. Gallen and become a freelance painter at the age of thirty.

After being rejected by the Academy, Nolde first attended Friedrich Fehr's private painting school in Munich, then in the spring of 1899 switched to Adolf Hölzel's in Dachau. There he came into contact with the Romantic style of painting filled with nature lyricism that was influenced by the Barbizon School, especially Jean-François Millet, and that fascinated all of

Europe shortly before the turn of the century. His engagement with the art of the old masters, with the works of Wilhelm Leibl, Hans von Marées, and especially Arnold Böcklin first led Nolde to an atmospheric, dark-toned compositional style. German nature lyricism became an important point of departure in his painting, but thereafter he sought to simplify his approach. His encounter with the painting of the late Impressionists, works by Vincent van Gogh, Paul Gauguin, and Edvard Munch, enriched his work as he developed his own pictorial idiom.

Nolde's apprenticeship and journeyman years ended in 1899 with a sojourn of several months in Paris. There he studied at the Académie Julian and visited the many exhibitions held in conjunction with the World Fair. He particularly admired the painting of Édouard Manet, considered a trailblazer of modern art. He subsequently visited the painters Viggo Johansen, Joakim Skovgaard, Vilhelm Hammershøi, and Jens Ferdinand Willumsen in Denmark. At this time he produced a great variety of works: light-filled seascapes in delicate greens, portraits of fishermen, and fantastic-grotesque drawings with ghostly figures and mythical creatures.

FLOWERS AND GARDENS – "THE RADIANT COLOURS OF THE FLOWERS AND THE PURITY OF THESE COLOURS, I LOVED THEM"

Emil Nolde became acquainted with the young actress Ada Vilstrup, whom he married in 1902. After brief stays in Berlin and Flensburg, the couple moved into a small fisherman's house on the island of Alsen in the Baltic Sea. In 1904 Nolde abandoned the soft tones of the Dachau school of painting. In a portrait of Ada, *Spring in the Room* (*Frühling im Zimmer*) (4), Nolde allowed the bright colours and free, spontaneous brush work of Impressionism to flood into his painting. He first painted pictures of flowers and gardens, inspired by the colourful gardens of his Alsen neighbours. While there Nolde began to explore both the expressiveness of colour and its appeal to the emotions: "With colour, with the medium, the technical issues, it was a difficult struggle. Everything I had adopted, learned, was useless, everything had to be discovered anew." (II, 107) During the next three years he produced a series of flower and garden pictures that are of particular importance in his artistic development.

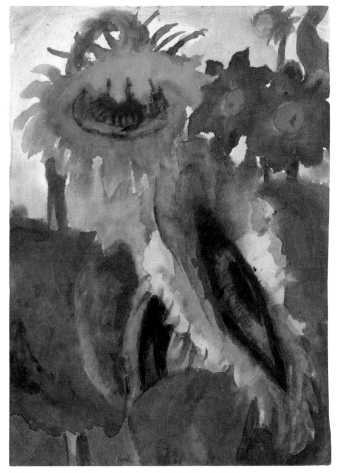

3 *Sunflowers in full-bloom*, watercolour, Nolde Stiftung Seebüll

They became a core motif "with which the painter begins his dispute with Impressionism, and in contact with nature intuitively develops his notion of the powerful effect and reliability of colour when applied spontaneously."[2] Wherever Nolde settled from then on, he planted flower gardens: on Alsen, in front of his house Utenwarf near Ruttebüll, and finally at Seebüll. In 1927, while his new house and studio in Seebüll was under construction, Nolde, by then nearly sixty, was already planning its much more lavish and ideosyncratic garden. Only a year after they moved in he was able to boast

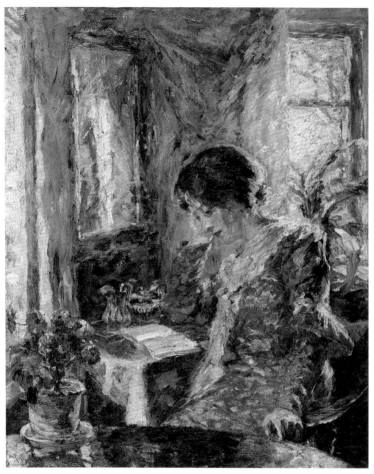

4 *Spring in the Room*, 1904, oil on canvas, Nolde Stiftung Seebüll

to his friend Hans Fehr about the "young garden with its burgeoning abundance of flowers, more beautiful than we ever had before."[3] At Seebüll he continued the large series of floral watercolours (3) he had begun at Utenwarf in 1918-20, mostly with sunflowers, poppies, tulips, and dahlias. The fluid transitions and accidental courses of the wet-on-wet painting on absorbent Japan paper follow the structure of the blossoms and leaves in their intense colouring.

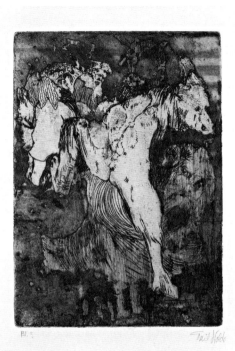

5 *Phantom*, 1905, etching,
Nolde Stiftung Seebüll

"GRAPHICS SHOULD BE CREATED
WITH THE SAME LOVE
AND DEDICATION AS PAINTINGS"

While Nolde was finding his way to colour as his proper means of ex-
pression, he also began making black-and-white prints. After isolated
earlier experiments, he produced in Berlin in 1905 a series of eight etchings
that he assembled as a portfolio with the name *Fantasies* (*Phantasien*) (5).
They mark the start of his graphic œuvre and are at the same time a first
culmination. Nolde worked on them like a man possessed; he was filled
with pictures and visions, and once he had mastered the new technique
they virtually erupted out of him: "I worked, scratched, and etched to the
point that everything around me, shirt, wallpaper, clothing, had to suffer."

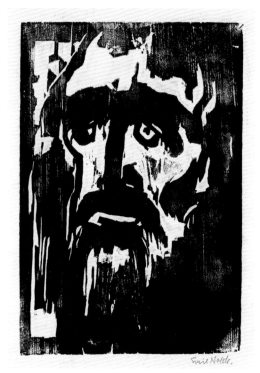

6 *Prophet*, 1912, woodcut,
Nolde Stiftung Seebüll

(II, 85) He summed up: "It was a submersion of one's entire being in work and expectation." (II, 110) Over the next two decades his graphic œuvre came to number 528 works, often in different printing states, sometimes left as a single copy.

During a sojourn in Hamburg in 1910 Nolde produced etchings and woodcuts of Hamburg's harbour that document a new sense of form in his prints. In woodcuts, which he had begun making in 1906, he now incorporated the structure of the material—the grain, flaws, cracks, unevenness, and irregular edges of the wooden block. These all became part of the artistic statement. Nolde strove to incorporate nature directly in the creative process. "I loved such collaboration from nature," he confesses, "indeed, all communion with nature: painter, reality, and picture." (II, 90) Within a short time some of his works, like the woodcut *Prophet* (6), would

number among the incunabula of German printmaking; this particular one even a programmatic work of German Expressionism.

Nolde's printmaking was a separate endeavour, yet at the same time closely related to his painterly œuvre. There are no barriers between the various genres; on the contrary they tend to fertilise each other. Nolde interpreted the motif of the dance, for example, in various forms and different mediums for an entire decade: first in the 'ring-a-ring-a-roses' dances typical of childhood, then in 1912 in the painting *Candle Dancers* (7), which in its exuberance, abandon, intoxication, and heightened colouring captures the ecstatic qualities of primitive cult dances. It was followed in 1913 by a large-format lithograph, and a few years later he took up the same subject in a woodcut and an etching.

BERLIN – "THERE WAS PLENTY TO LOOK AT EVERYWHERE"

Nolde took inspiration for his art from two very different worlds: on the one hand that of his remote homeland in the border region between Germany and Denmark, and on the other from the pulsating metropolis Berlin. Beginning in 1905 he spent the winter months in the city, where he had his own apartment and atelier, first on Tauentzienstrasse and later on Bayernallee. Berlin had become one of Europe's major metropolises, and with its dance, theatre, and cabaret a distinct attraction and source of inspiration for both visual artists, like the painters of the artists' group *Die Brücke*, and writers like Georg Heym and Gottfried Benn. Nolde engaged with the big city in his pictures especially in the years 1910/11. "Every evening at eleven I would put on my dark trousers and the black frock coat from St. Gallen, which would soon become outdated. My Ada too would put on her best dress, and we would head out to masked balls, to cabarets, to the Ice Palace. And then go on to public taverns, where sallow as powder and impotent boulevardiers and hectic ladies from the demimonde sat in their elegant, daring wraps, worn as though by queens. And on it went into the cigarette haze of early-morning cafés, where new arrivals from the provinces, sit innocently next to streetwalkers, half dozing in a champagne daze." (II, 147)

Max Reinhardt, the director of the *Deutsches Theater* and the *Kammerspiele*, would give Nolde free tickets. In the dark auditorium Nolde, assisted

by Ada, painted in watercolour and ink with swift, precise brush strokes a series of more than 300 watercolours and ink drawings concentrating on the expressive possibilities of the figures, their movements and gestures. Graphic works, etchings and lithographs, and a series of 17 paintings were also based on Berlin nightlife, their central theme the bright, glittering atmosphere (8): "I would draw and draw, the light of the halls, the surface tinsel, all the people, for better or for worse, whether from the demimonde or totally degenerate, I drew this other side of life with its heavy makeup, with its grime and depravity." (II, 147f.)

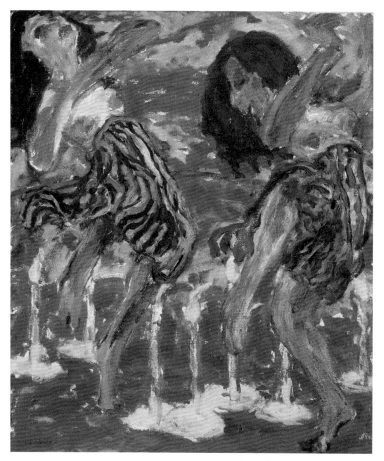

7 *Candle Dancers*, 1912, oil on canvas,
Nolde Stiftung Seebüll

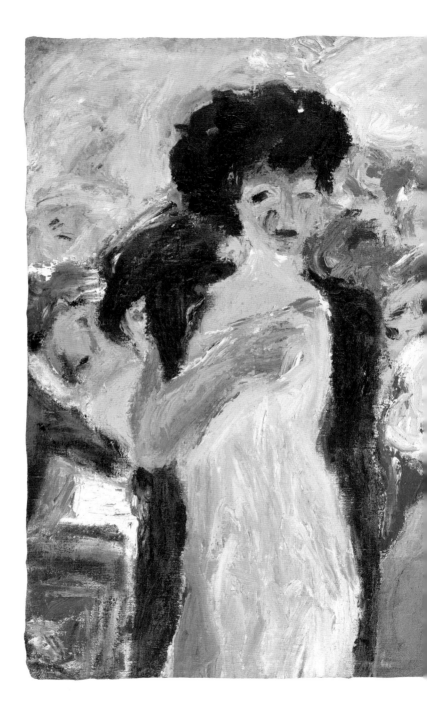

8 *Party*, 1911, oil on canvas,
Nolde Stiftung Seebüll

THE SOUTH SEAS – "I HAD TO GET TO KNOW THE UNKNOWN"

Nolde's art is characterised by a search for primal origins. "My interest in the remote, the primeval, and primitive races was especially strong," he writes in his autobiography (I, 166). He had been attracted to the art of primitive peoples ever since 1910, when he drew a number of objects in Berlin's Ethnology Museum in coloured pencils. From the beginning of October 1913 to the late summer of 1914 he was able to take part with his wife Ada in the 'Medical-Demographic German–New Guinea Expedition' organised by the Reich Colonial Office. Nolde's special task was "the 'demographic' part, the study of the racial peculiarities of the populace." (III, 15). Unlike Paul Gauguin or Max Pechstein, Nolde had no desire to

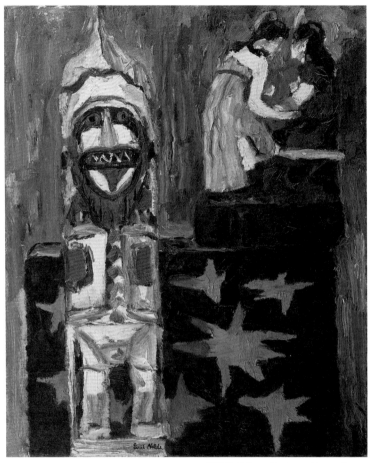

10 *Still Life H (Large Tamburan, Moscow Group)*,
1915, oil on canvas, Nolde Stiftung Seebüll

9 *Jupuallo*, 1914, watercolour, Nolde Stiftung Seebüll

take part in the life of the native peoples; he saw progressive colonialisation from a critical distance and as a threat. In his works the landscape plays only a subordinate role, what fascinated him were the indigenous people presumably still living in harmony with nature. Nolde doggedly made sketches and watercolours of whatever he encountered.

From the South Seas he also brought back objects for his varied collections. In them Chinese and Russian porcelain stood next to ancient Egyptian religious figures, African wooden fetishes next to Japanese theatre masks, totem figures from Oceania next to German baroque Madonnas, folk crafts next to Frisian stoneware, all of which helped to inspire his numerous still lifes. Between 1911 and 1929 he produced more than a hundred paintings featuring masks and figurines (10), and continued painting watercolours with related motifs until well into the 1950s.

His fascination with the unfamiliar repeatedly took him abroad, to Switzerland, Denmark, Italy, Sweden, England, France, and Spain. Most of these travels left their marks on his art.

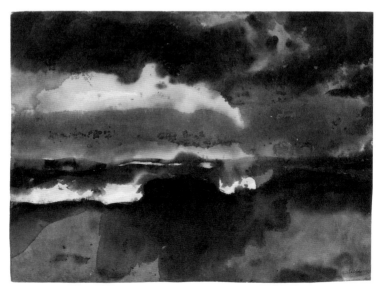

11 *Sea (Violet-Yellow-Green)*, watercolour, Nolde Stiftung Seebüll

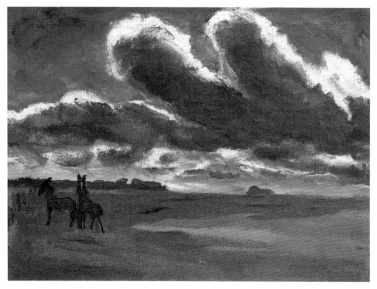

12 *Landscape with Young Horses*, 1916, oil on canvas, Nolde Stiftung Seebüll

LANDSCAPES – "MY WONDERLAND FROM SEA TO SEA"

His homeland, which was "like a fairy tale" to him (II, 13), continued to be a central source of strength: the sparse landscape with its low-lying horizon and high, dramatic skies frequently filled with imposing black-grey cloud formations that constantly changed the mood of the landscape with shadows, light, and colour. And of course the sea: Nolde was fascinated with this infinite and endlessly changing element all his life. As early as 1901 he made paintings of the sea in various shades of grey in North Jutland; ten years later these were followed by a series of 20 autumn seascapes on Alsen. In 1921, in the first monograph on him, his friend the art historian Max Sauerlandt wrote: "Nolde knows the sea as no artist before him has known it. He does not look at it from the beach or from a ship, he sees it as it lives in itself, having nothing to do with man, as the churning, ever-changing, utterly self-sufficient, self-depleting, divine primeval element that has preserved to this day the untamed freedom of the first day of Creation."[4]

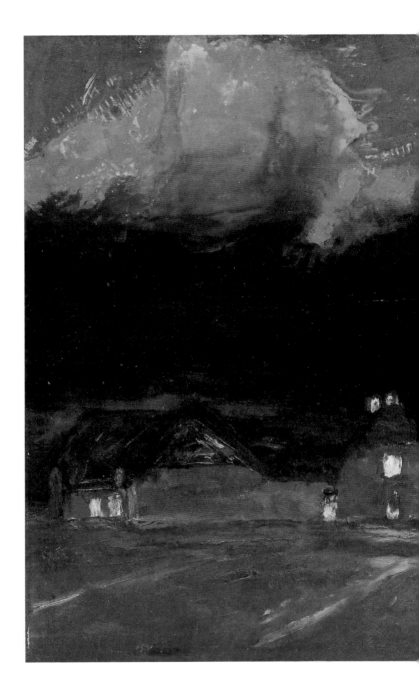

13 *Sultry Evening*, 1930, oil on plywood, Nolde Stiftung Seebüll

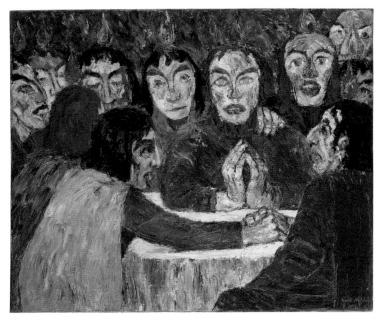

14 *Pentecost*, 1909, oil on canvas, Staatliche Museen zu Berlin –
Stiftung Preussischer Kulturbesitz, Neue Nationalgalerie

RELIGIOUS PICTURES – "RICHEST ORIENTAL FANTASY"

Nolde subscribed to the Romantic view of art; he was convinced of the
artist's unique creative power. In part this went back to the world of ideas
from his long-ago childhood, when every evening he would read in the
Bible. He finally assembled a canon of 'Bible and legend pictures,' to which
he assigned 51 paintings that he numbered among the highlights from his
life's work. To him they represented the "shift from external visual charm
to values sensed internally. They became milestones—perhaps not only in
my work." (II, 125) A key experience for him was the summer of 1909, in a
house next to the sluice in the fishing village of Ruttebüll near the North
Sea. Along with a series of watercolour heads of apostles, he managed to
paint his first three proper biblical pictures *Last Supper* (*Abendmahl*), *The
Mocking* (*Verspottung*), and *Pentecost* (*Pfingsten*) (14). The paintings are
not illustrations of specific Bible texts, but products of his own imagin-
ation, drawing on his childhood memories and his fantasy: "The works of

Homer and Dante sadly lie so very far away from me as something I don't own, perhaps cannot own. The Bible I know, and all the pictures in it I see vividly, I grew up with them."[5]

The religious pictures triggered passionate controversy from the start. The painter Max Liebermann, president of Berlin's Secession, is quoted as having announced in 1910: "If that picture is exhibited I'll resign!" Nolde's *Pentecost* thus set off an intense public debate that led to the breakup of the powerful Berlin Secession and the founding of the New Secession.

In 1911/12 he produced his largest picture, his magnum opus, the nine-part *Life of Christ* (*Das Leben Christi*) (16): "There are 9 pictures: 8 smaller ones and 1 large one: the three crucified figures in the centre, the women on the left and soldiers on the right. I had to tackle such a major assignment sometime. But the effect here was so powerful that I could scarcely show the work to anybody, and only a few of the few who saw it were able to fully comprehend both its subtlety and its vehemence."[6] In his autobiography he indicates that the first panels had been placed side by side "perhaps accidentally," until he thought of others he might add to them: "In that all the pictures complemented each other artistically, they were meant to have a very great, powerful pictorial effect, imbued with religious feeling and spirituality: 'The Life of Christ.'" (II, 191)

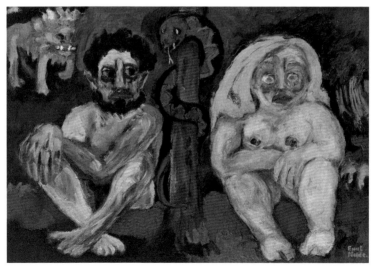

15 *Paradise Lost*, 1921, oil on canvas, Nolde Stiftung Seebüll

16 *The Life of Christ*, 1911/12, oil on canvas,
Nolde Stiftung Seebüll

FANTASTIC GROTESQUES –
"FORAYS INTO THE DREAMLIKE,
THE VISIONARY, THE FANTASTIC"

Nolde's fantastic, grotesque pictures constitute a special group in his œuvre, one that ultimately led him to freely imagined figural images. With these works, created "beyond reason and knowledge" (II, 200), he freed himself from the representation of natural phenomena and allowed himself to be guided solely by his imagination and personal experience. "All my gift for figuration was meant to express itself in freedom, past, present, future, all the same, I only needed to follow my own whims." (II, 200) The subject matter was already established in his early work with the Mountain Postcards and his first painting, *Mountain Giants*. A few years later, in the summer of 1901 in Lildstrand, a small fishing village in northwest Jutland, he produced visions of fabulous creatures, exotic animals, and monsters that also make their appearance in his graphic works. These were followed by the fantastic watercolours from Utenwarf and in 1919 by those from Hallig Hooge (17). There he painted in watercolours and with reed pen and ink "a number of quite remarkable little sketches and magically imaginative pictures, astonishing the painter himself. His room was enlivened by

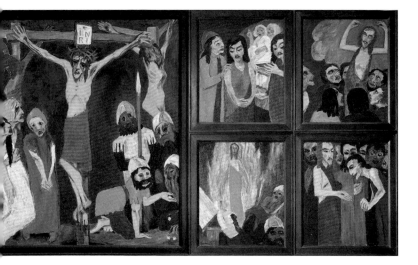

the most curious creatures with their antics, and they accompanied him on his Hallig walks, almost visibly fluttering about him. Only a few referred back to images he had produced before, almost all of them were a new approach, and needed new descriptions." (IV, 13) These encounters with strange creatures led Nolde even further in a number of oil paintings. (18) His attachment to this world and its nature is an essential feature of his art. Inseparably tied to his homeland, he responded to "the crepuscular, fantastic atmosphere of the north, these hours of imaginative stirrings, in life and in art." (I, 170)

WATERCOLOURS AND UNPAINTED PICTURES –
"THE WORK TOOK SHAPE
UNDER THE MOVEMENTS OF MY HANDS"

Nolde was one of the greatest watercolourists in art history. His watercolours equal his works in oil, their picture subjects the same. The technique of wet-in-wet ideally suited his wish for immediacy and spontaneity. After the death of his wife Ada, in 1948 he married Jolanthe Erdmann, the daughter of his friend Eduard Erdmann. She recalled how the watercolours

took shape: "He paints so wet that he sometimes has to lay a sheet he has begun aside for a while to let it dry before he can work on it further. In the meantime he'll begin a new one. If he feels that a colour is not concentrated enough, he will take his brush and saturate the paper with the dripping pigment at that spot again and again. So it happens that a watercolour is not uniformly translucent if you hold it up to the light. Frequently a light colour is more opaque than a dark one. And suddenly against the light completely different colour values can appear. Dark blue spots can become radiant, yellow, lighter spots even look dark… . It flows out of his hand, including all the changes that take place in the paper on their own. The pictures come into being, they evolve like guided yet autonomous creatures."[7]

In the autumn of 1931, for example, Nolde painted a series of freely imagined, large-format watercolours of the highest quality, the *Fantasies* (*Phantasien*). (20) The works are born of colour, they arise in part thanks to the accidental courses and irregularities of the colouring. The subjects are difficult to identify, they are strange creatures from fairy tales and sagas, now human, now animal, now both at the same time, goblins, ghostly

17 *Dancer*, 1919, watercolour, Nolde Stiftung Seebüll

18 *Encounter on the Beach*, 1920, oil on canvas, Nolde Stiftung Seebüll

figures, wild visions, elegiac single figures, also groups, but above all couples, youthfully exotic ones or others with the tense relationship between an old man and a young woman.

Nolde's work was brought to an end on August 23, 1941: the president of the Reich Chamber of the Visual Arts wrote to him that effective immediately he was to abstain from "all professional—even avocational—activity in the realm of the visual arts."[8] Only a few years before Nolde had hoped to be recognised by the National Socialist regime, but 1,052 of his works had been confiscated from German museums in 1937 and publicly defamed during the campaign against so-called 'degenerate art.' Nolde retreated to Seebüll. On February 5, 1944, he wrote in his *Marginal Notes* (*Worte am Rande*), a kind of diary that accompanied his work on the *Unpainted Pictures*: "Paint painter! Why should I paint, a proscribed painter? It is difficult with one's hands tied. My pictures weep. Their home is a prison. They only wanted to rejoice. They are deathly sad. My pictures."

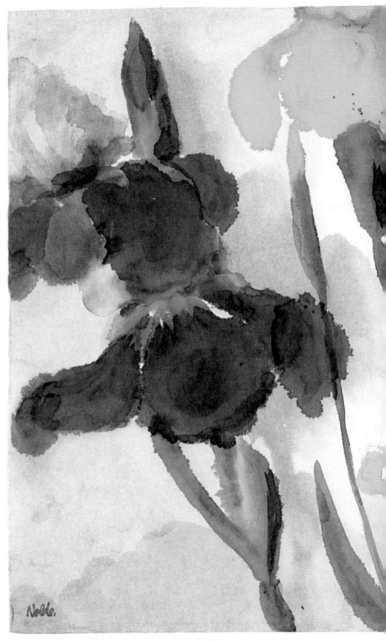

19 *Irises and Poppies*, watercolour, Nolde Stiftung Seebüll

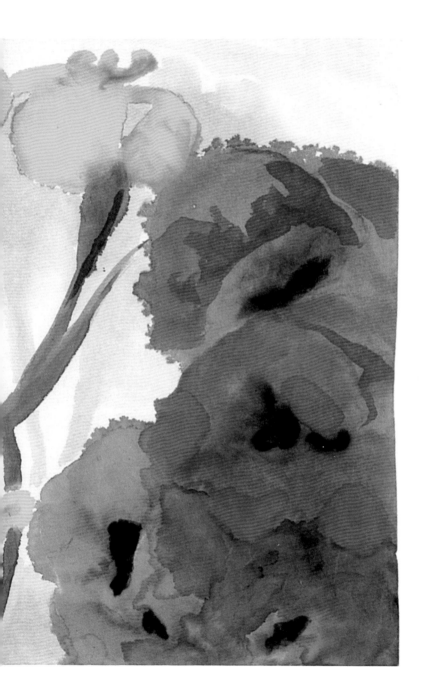

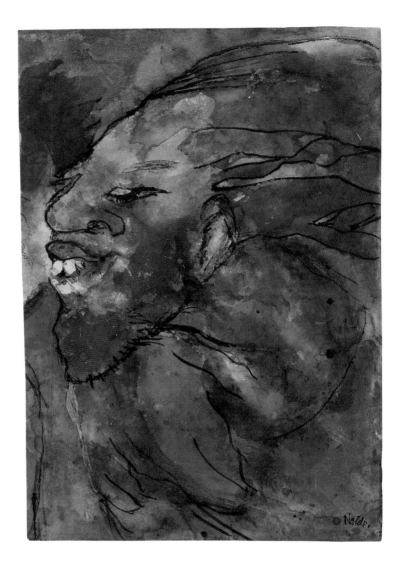

20 *Mythical Figure*, from the series of *Fantasies*, 1931–35,
watercolour, Nolde Stiftung Seebüll

21 *Large King,* from the series of
Unpainted Pictures, 1938–45, watercolour,
Nolde Stiftung Seebüll

22 *The Large Gardener,* from the series of
Unpainted Pictures, 1938–45, watercolour,
Nolde Stiftung Seebüll

Despite the ban, he painted more than 1,300 small-format, brightly coloured watercolours with the same subject matter as the *Fantasies*. *The Unpainted Pictures* are a high point in Nolde's late work and unique in art history (21, 22). He wrote: "Most of these small, free, fantastic sheets were produced in a secretive, out-of-the-way corner of the house during the years of my proscription. They were given to friends for safe keeping, they could not be seen by anyone without an eye for art. Mostly they are sketches for figural pictures, often grotesque and wild, natural as well as unnatural, all possibilities: deliberate and fortuitous, utilising both what I knew and what I felt" (IV, 147).

LATE WORK – "WHEN THE SHACKLES FELL"

With the end of Nazi rule Nolde's "hands were untied." The nearly eighty-year-old "first painted a few garden pictures with large, radiant red poppies, so as to accustom myself to the colours" (IV, 175). Between 1945 and 1951 he produced more than 100 paintings, many of them based on the *Unpainted Pictures*. After breaking his arm, he no longer had the strength to work in oils, and painted only watercolours. Now his painting no longer

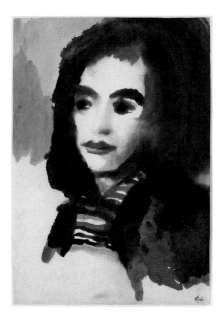

23 *Portrait of a Woman (Jolanthe Nolde)*, ca. 1950, watercolour, Nolde Stiftung Seebüll

exhibited the forcefulness of Expressionism; the unsettling, ecstatic, and dramatic gave way to the epic. "A mature humanity experiences the mythical in nature in the sonorous enchantment of its miraculous colours and turns it into radiant legend."[9] His late work makes no claim to compete with contemporary abstract art. In its expressive content it is softer, less strident, and for that reason seems more innocent. In its subject matter and pictorial vocabulary it reverts to those from before his proscription, and exhibits the painter's ultimate authority and strength.

CHRISTIAN RING *has been the Director of the* Stiftung Seebüll Ada und Emil Nolde *since 2013; he had served as assistant director since 2011. After studying art history and philosophy in Kassel and Bonn, he served on the staffs of the* Hamburger Kunsthalle *and the* Museum Giersch *in Frankfurt am Main.*

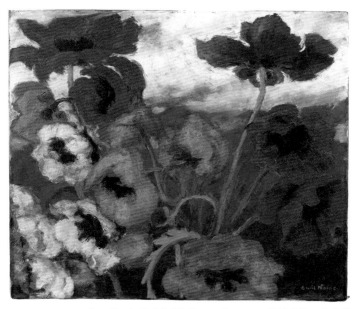

24 *Large Poppies (Red, Red, Red)*, 1942, oil on canvas, Nolde Stiftung Seebüll

The quotations referenced with Roman numerals and Arabic page numbers come from Emil Nolde's four-volume autobiography, Cologne 2002. The quoted letters are in the archive of the Nolde Stiftung Seebüll. The quotations in the headings are taken from: II, 133; Emil Nolde to Alfred Heuer in a letter dated July 12, 1929; II, 100; Emil Nolde to Hans Fehr in a letter dated Christmas 1917; II, 148; I, 166; II, 13; II, 217; *Worte am Rande*, July 8, 1943; II, 201; IV, 148.

1 Werner Haftmann, *Emil Nolde*, Cologne 1958, p. 102.
2 Ibid.
3 Letter from Emil Nolde to Hans Fehr dated September 20, 1928.
4 Max Sauerlandt, *Emil Nolde*, Munich 1921, p. 49.
5 Letter from Emil Nolde to Max Sauerlandt dated April 10, 1916.
6 Letter from Emil Nolde to Nelly and Hans Fehr dated February 28, 1912.
7 Jolanthe Nolde, "Beim Malen zugeschaut," in: Manfred Reuther, ed., *Emil Nolde*, Cologne 2010, p. 295.
8 Painting ban and expulsion from the Reich Chamber of the Visual Arts by its president, Adolf Ziegler, letter dated August 23, 1941.
9 Werner Haftmann, *Malerei im 20. Jahrhundert*, Munich 1957, p. 124.

AN ARTIST'S LIFE
ON THE
GERMAN-DANISH BORDER

Hans-Joachim Throl

In 1929 Paul Ferdinand Schmidt appended excerpts from the artist's letters to his essay in the issue of *Junge Kunst* dedicated to Emil Nolde. The first of them, dated October 14, 1906, was addressed to the director of Hamburg's regional court and art-lover Gustav Schiefler, whom Nolde had only recently met and who would become a major champion of his art. In it Nolde briefly described his career: "As for my past, a few brief notes: I was born near Tondern in 1867. My father had a farm there, and was determined that I should become a farmer as well. At 17, despite everything, I escaped from that, and then until age 30 worked as a craftsman, in factories and in the applied arts. But then again—once I had acquired the means—I dropped everything and devoted myself to training in art. I spent time in Munich, Paris, Copenhagen, and Berlin, roughly a year in each. For the past four years I have been painting the way I think it should be done."[1]

Nolde's parents lived in the village of Nolde, to the north of the Prussian province Schleswig-Holstein. Many years later he explained: "But my art is deeply rooted in the soil of my tiny homeland. Even though my knowledge and my desire for artistic breadth and representational possiblities extend to the remotest primitive realms, whether in reality or whether in my imagination or my dreams—the land of my birth remains my home" (IV, 35).

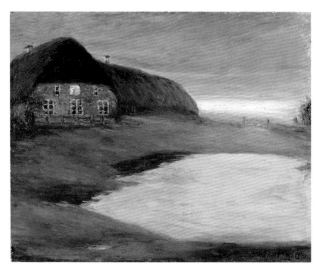

25 *Home*, 1901, oil on canvas, Nolde Stiftung Seebüll

He absolved his apprentice and journeyman years by serving as a drawing teacher in St. Gallen, for example, and travelling a great deal. And between 1905 and 1940 he regularly spent the winter months in Berlin. Yet to a very considerable extent he spent his life near the German-Danish border. The old Danish highway that runs parallel to it from Tondern, near the west coast, via Sonderburg out to the east end of the island of Alsen, in the calmer Baltic Sea, was his lifeline, and all the places where he lived lay next to or within reach of Denmark's present-day A 8 highway.[2] Nolde's art contains an uncommonly powerful rootedness in his homeland. This landscape between the seas, with its uncommonly vast sky, was the source of his inspiration.

A DIFFICULT START – THE YEARS ON ALSEN

From roughly 1902 on, Nolde thus painted "the way I think it should be done." This second, "artistic part" of his life, as he put it, began "afresh and with forthrightness" (I, 247). This was the year he married the Danish actress Ada Vilstrup and officially changed his name from Hansen to Nolde.

The following years were not easy for the young couple, for "there were struggles, internal and external, difficult and bitter," as Nolde wrote in the foreword to the second volume of his autobiography, which begins with this time (II, 7). Starting in 1903 they lived on the island of Alsen, near Sonderburg, where Nolde rented a small fisherman's cottage and erected a small plank atelier on the shore. For years Ada and Emil Nolde lived in considerable financial distress. In the smaller garden pictures he painted there, like *Trollhois Garden* (*Trollhois Garten*) (29), Nolde occasionally incorporated a female figure in the background of his composition. Here it is his wife Ada.

In 1906 the members of *Die Brücke* invited Nolde to join them: Karl Schmidt-Rottluff wrote to him: "… we have here wished to pay tribute to your storms of colour." Nolde accepted the invitation, but left the group again in the autumn of 1907, as he did not like "its increasing uniformity" (II, 99). Nolde would continue to be the maverick, an artist who wished to go his own way.

NOLDE DISCOVERS LITHOGRAPHY

Nolde produced his first lithographs—figural works and landscapes—in 1907. These he drew with a brush dipped in black on transfer paper then pressed onto the stone. In the lithographs that followed, beginning in 1911 the artist worked directly on the stone. *Church and Ship, Sonderburg* (27) presents a view of St. Mary's Church with its tower and prominent roofline across the Alsensund. The ship lying next to the quay, whose mast rears up next to the church tower, could have been a freighter. A picture postcard of Sonderburg from this time (26) offers a view from a similar vantage point. Nolde's lithographs are deserving of particular attention. "They are the first pictures," Martin Urban has asserted, "to contain an expressive element in the truest sense. … Simplification and abstraction, tension between volume and space as enhanced by the contrast between black and white, give the subject matter a formal grandeur, expose its dramatic shapes. There is something threatening, outrageous in these prints that could only shock his contemporaries."[3]

Nolde's composition is rendered in strong, lively brush strokes. From the middle section, so concentrated that it is nearly impossible to distinguish

26 Picture postcard from Sonderburg, ca. 1910

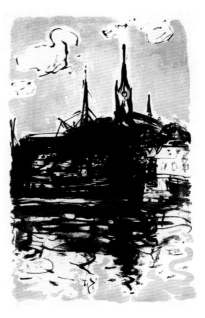

27 *Church and Ship, Sonderburg*, 1907 (1915), brush and ink lithography, private collection

been the ship's hull and the church tower, the foreground of the drawing loosens up, with the surface of the harbour mirroring the clouds in the sky. And here, where the black brush drawing offers empty spaces, Nolde later placed additional accents with printing ink. This he only did in 1915, when, as here, he printed over a few lithographs from 1907 in colour.

A SUMMER OF CONSEQUENCE — BIBLICAL PICTURES

In 1909 Nolde spent the summer in Ruttebüll, on the west coast. He continued to struggle over his artistic direction. "Being true to nature and reproducing it precisely does not produce a work of art," he wrote. "It is the reinterpretation of nature in the light of one's own soul and spirit that makes the work a piece of art" (II, 120).

After a severe case of poisoning from polluted drinking water, Nolde followed an "irresistable desire to portray a profound spirituality, religion, and deep emotion … but without much preconception and thinking or deliberation" (II, 121). This led him to his first religious pictures, among

them *The Last Supper* (*Abendmahl*) and shortly afterward *Pentecost* (*Pfingsten*) (14). In his autobiography Nolde mentions that already as a schoolboy he had painted over all the pictures in his book of Bible stories, "and at that time lived in a constant intoxication with colour" (I, 41). His childhood impressions were of considerable importance for his religious pictures, a significant component of his total œuvre.

IN THE METROPOLIS BERLIN AND
ON THE JOURNEY TO THE SOUTH SEAS

In 1910 Nolde leased an apartment and atelier in Berlin at Tauentzien-strasse 8. In the following winter he produced a cycle of pictures of the city's nightlife, scenes from cafés, cabarets, dance halls, and theatres, in which he sought to capture a world altogether foreign to him. And in Berlin he focused intently on the art of primitive peoples. So it was with delight that he accepted an invitation to join an expedition to New Guinea sponsored by the Reich Colonial Office, especially since his wife could accompany him. Their South Sea journey took them in 1913 by way of Moscow, Tokyo, Peking, Shanghai, and Manila to Rabaul. In numerous watercolours he captured his impressions of the natives and their dances and rituals, as well as of tropical landscapes and junks on the Han River and in the China Sea. As he had in Berlin, he attended the theatre with his wife in Japan and translated what he saw into art (28). He records the experience in his autobiography: "The play itself was heraldically stylish, with sweeping, heroic gestures, the masks and actors' poses highly elegant and beautiful. The female roles were played by male actors" (III, 38).

On their return trip the expedition was surprised by the outbreak of the First World War; his 19 oil paintings from the South Sea trip were confiscated—though later recovered. The Noldes returned home unscathed.

A NEW HOME AT UTENWARF

Nolde's figural works frequently present double portraits. "Duality had come to play a major role in my pictures. In conjunction or opposition: man and woman, joy and sorrow, god and devil. The colours were also

opposed to each other: cold and warm, light and dark, faint and strong"
(II, 200). Nocturnal creatures, goblins, ghostly figures, witches, mermaids,
giants, and over and over again opposed pairs characterised his figural
world, which was unquestionably influenced by Nordic mythology.

Nolde painted only a single double portrait of himself and his wife: *A. and
E. Nolde* (p. 8), from 1916. As Manfred Reuther has written, it is possible to
see it "as the artist's summing up after the important years on Alsen and at
the beginning of a new phase."[4] In the previous year Ada and Emil Nolde
had moved from Alsen to Utenwarf, near Tondern.

Here, too, Nolde created a garden, and after his engagement with religious
motifs it once again inspired him to paint flowers: "… when after a six-
year pause I again painted garden pictures, they were more profoundly,
more grandly conceived and imbued with greater melancholy" (II, 215).
Flower Garden (Marigolds) (*Blumengarten [Ringelblumen]*) (30), from 1919,
shows Nolde's development of a highly ideosyncratic, expressive painting
style.

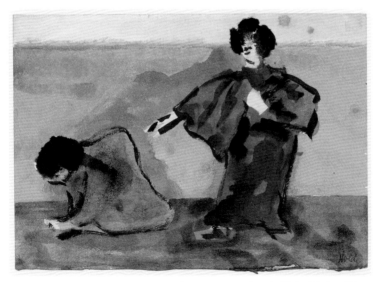

28 *Japanese Theatre*, 1913, watercolour, Städtische Galerie Wolfsburg

29 *Trollhois Garden*, 1907, oil on canvas, Nolde Stiftung Seebüll

DEPARTURE FOR SEEBÜLL

After a plebiscite in 1920, Nolde's home became part of Denmark; he was given Danish citizenship, which he retained for the rest of his life. Nolde was receiving increasing public recognition, evidenced by a number of exhibitions and sales to museums. In 1926 he bought a knoll and its farm, called Seebüll, on the German side of the border a few kilometres west of his birthplace. Once the house and atelier they designed had been constructed, the Noldes would live there for the rest of their lives. It took ten years for the place to be finished. There, as well, Nolde laid out an extensive garden, with paths in the shapes of the couple's initials, A and E. The garden is maintained as Nolde created it to this day.

In the summer of 1930, while Ada was overseeing construction work at Seebüll, Nolde worked undisturbed until well into the autumn on Sylt:

30 *Flower Garden (Marigolds)*, 1919, oil on canvas, Nolde Stiftung Seebüll

"... and I was especially eager to see once again and capture the sea in all its untamed grandeur. ... I painted whatever appeared before my papers and canvases: the clouds, the waves, a dune fantasy, and then my passionate seascapes with crashing waves and spray" (IV, 101, 104). Again and again he came back to this motif, rendering the mysterious power of the sea in its changing moods, no less dramatic as a pictorial element than the sky and the clouds (31).

LEAVETAKING

Emil Nolde died in his eighty-ninth year on April 13, 1956. Under the terms of his will, the house and garden at Seebüll, with permanent holdings of paintings, watercolours, drawings, and graphics, are open to the public

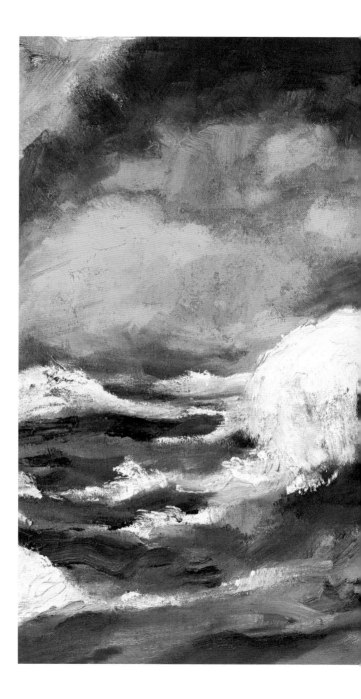

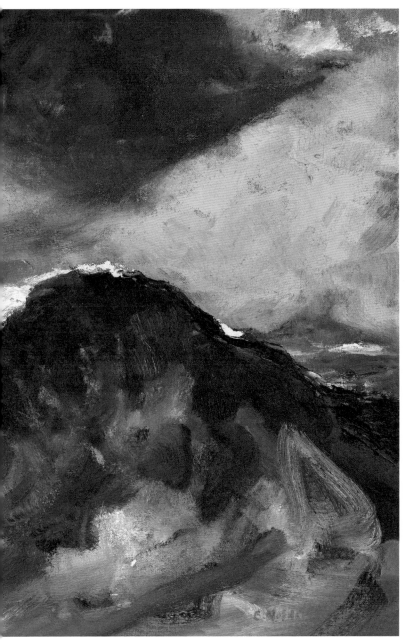

31 *Tall Breaker*, 1948, oil on canvas, Nolde Stiftung Seebüll

with annually changing exhibitions. *The Stiftung Seebüll Ada und Emil Nolde* administers the artist's estate. The two found their last resting places in a crypt at the edge of Seebüll's glorious garden.

Early in his memoirs the painter wrote: "Scholarly art critics call me an Expressionist; I don't like this limitation" (II, 201). Nonetheless, Emil Nolde has gone down in history as one of the leading Expressionists. His richly varied œuvre continues to be accorded the highest esteem to this day.

HANS-JOACHIM THROL *is the Chairman of the Board of Directors of the* Stiftung Seebüll Ada und Emil Nolde. *The Wolfsburg attorney and art collector has spent years studying the life and work of Emil Nolde, and is recognised for his profound knowledge of his art.*

The quotations referenced with Roman numerals and Arabic page numbers come from Emil Nolde's four-volume autobiography, Cologne 2002. The letter quoted is in the archive of the Nolde Stiftung Seebüll.

1 Paul Ferdinand Schmidt, *Emil Nolde*, Junge Kunst volume 53, Leipzig and Berlin 1929, p.13.

2 See Hans Peter Johannsen, "Emil Noldes Leben in seiner Heimat an der Grenze," in: *Emil Hansen aus Nolde, der Maler aus dem schleswigschen Grenzland. Eine Gestalt zwischen Deutschland und Dänemark*, edited by the Flensburger Studienkreis, Flensburg 1974, pp. 46 f.

3 Martin Urban, *Emil Nolde – Landschaften. Aquarelle und Zeichnungen*, Cologne 1980, p.18.

4 Manfred Reuther, "'… ein paar Bildnisse nach meiner Ada' (1903/04)," in: *Bewundert, gefürchtet und begehrt – Emil Nolde malt die Frauen*, edited by Manfred Reuther, exh. cat. Berlin branch of the Nolde Stiftung Seebüll, Cologne 2010, p.13.

BIOGRAPHY

Emil Nolde
1867–1956

1867–1884 Emil Nolde is born as Hans Emil Hansen in the village of Nolde, near Tondern, in northern Schleswig, on August 7, 1867. He grows up there on a farm as the sixth child of Niels and Hanna Christine Hansen and attends the one-room village school. He begins his first painting experiments at the age of eight. Nolde's desire to become a painter finds no support from his father, who envisions him as a farmer or craftsman. After finishing school Nolde works on the farm for a year, until his father finally allows him to apprentice as a wood carver in the Sauermann furniture factory in Flensburg.

1884–1888 During his four-year training as a sculpture assistant Nolde receives instruction from Heinrich Sauermann and the portrait painter Jacob Nöbbe, and in his spare time produces his first independent drawings: facial types, caricatures, and portraits. Among his last carvings as an apprentice are four *Pensive Owls* for Theodor Storm's writing table.

1888–1891 Nolde works as a carver in furniture factories in Munich and Karlsruhe. He attends classes at the School of Applied Arts and secretly the life drawing class at the art school. In the autumn of 1889 he moves to Berlin, first making his living from odd jobs. In early 1890 he works as a draftsman and modeler in a factory for fancy goods, later in a furniture factory. He spends the summer at his parents' farm to recover from a bout of tuberculosis. In the autumn he returns to Berlin, but is summoned back to his father's deathbed before Christmas.

1892–1897 He is employed at the Industry and Applied Arts Museum in St. Gallen as a teacher of mechanical drawing. With his pupil Hans Fehr he begins a close, lifelong friendship. He paints his first watercolour landscapes, which he shows at exhibits in the St. Gallen Kunstverein. Beginning in 1894 he paints a series of depictions of Alpine peaks as figures from saga and fairy tales, which he has printed in large editions as *Mountain Postcards* and which sell very well. With his earnings he is able to resign his post and work as a freelance painter. He paints his first oil painting, *Mountain Giants (Bergriesen)* in 1895/96.

32 Parents Niels and
Hanna Christine Hansen

33 Emil Hansen [Nolde] as an apprentice
in Flensburg, ca. 1886

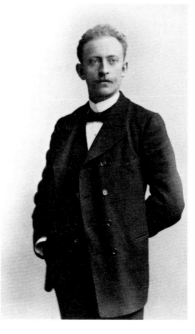

34 Emil Hansen [Nolde] while teaching
in St. Gallen, ca. 1896

1898-1900 Nolde had hoped to study under Franz von Stuck at Munich's Art Academy, but is rejected. In 1898 he attends the private painting school of Friedrich Fehr in Munich, and in the following year transfers to Adolf Hölzel's in Dachau. In the autumn of 1899 he sojourns for several months in Paris, studying life drawing at the Académie Julian. There he becomes acquainted with Paula (Modersohn-) Becker and Clara (Rilke-) Westhoff. In 1900 he travels to Jutland and Copenhagen, where he rents an atelier.

1901-1902 He spends the summer in the fishing village of Lildstrand on the north coast of Jutland. During this time he meets the 22-year-old actress Ada Vilstrup, whom he marries in Frederiksberg on February 25, 1902. At the same time he changes his name to Nolde. The newlyweds first live in Nolde's atelier in Berlin, then spend the summer in Jutland. In the autumn, after Ada is released from an extended hospital stay, they rent an attic apartment in Flensburg.

1903-1905 The Noldes move to the Baltic Sea island of Alsen in May 1903. In the autumn Nolde rents a fisherman's house near Guderup, and works in an atelier he has built himself out of planks on the nearby beach. To ease their financial distress, Ada plans to work in Berlin as a singer in variety shows, however she again falls ill, and to recuperate travels with Nolde to Italy. In late 1905 Nolde produces his first graphic works.

1906-1909 The young painters of *Die Brücke* invite Nolde to join them. He accepts, but withdraws from the group again in 1907. He begins a friendship with Karl Ernst Osthaus and Gustav Schiefler, and meets Edvard Munch. Colour becomes his characteristic means of expression. In 1907/08 he visits his friend Hans Fehr a number of times in Jena and in Cospeda. In 1908 he becomes a member of the Berlin Secession, and plans, in opposition to its dominance, an international artists' association with Munch as mentor, but Munch declines. In the summer of 1909 he paints his first religious pictures at Ruttebüll on the North Sea coast.

1910-1912 Major exhibitions in Hamburg, Essen, Jena, and Hagen. After a run-in with its president Max Liebermann, Nolde is expelled from the Berlin Secession and instead becomes a member of the New Secession. In Berlin Nolde rents an atelier and apartment on Tauentzienstrasse that he

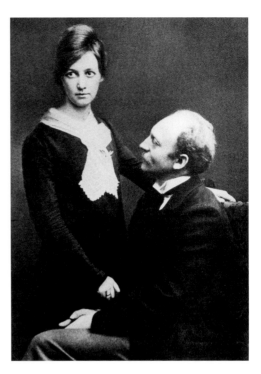

35 Ada and Emil Nolde,
wedding photograph,
Copenhagen 1902

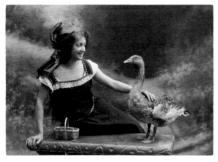

36 Ada Nolde as the "Goose Girl," Berlin 1904

37 Ada and Emil Nolde,
Berlin 1908

maintains until 1929. He there paints pictures of the big-city nightlife. In 1911/12 he paints his nine-part *Life of Christ.*

1913–1914 Purchases the farmhouse Utenwarf, near Mögeltondern on the North Sea. From the beginning of October 1913 to mid September 1914 the Noldes take part in the Reich Colonial Office's 'Medicinal-Demographic German–New Guinea Expedition' to the South Seas. While they are on their homeward voyage the First World War breaks out, and the luggage they had sent ahead, containing the paintings he had done during the trip, is confiscated by the English.

1915–1918 In 1915 Nolde produces 88 paintings, including pictures after sketches he had made in the South Seas. In 1916 the Noldes move from Alsen to Utenwarf. Nolde declines a professorship at the Karlsruhe Academy. Watercolours take on increasing importance in his art.

1919–1925 Nolde becomes a member of the Work Council for Art. On Hallig Hooge in the North Sea he paints a series of fantastic watercolours. After a plebiscite in 1920 northern Schleswig, and with it Utenwarf, becomes Danish, whereupon Nolde is given Danish citizenship, which he retains for the rest of his life. In 1921 he travels to England, where he reclaims his confiscated South Sea paintings. Later the Noldes travel to Spain. Max Sauerlandt writes the first monograph on Nolde. Travels in 1924/25 take him to Munich, Italy, and the Riesengebirge.

1926–1932 Nolde gives up the farmhouse Utenwarf in favour of the knoll at Seebüll, where he builds a new house and atelier. In 1927, on the occasion of his 60th birthday, a 'jubilee exhibition' is mounted in Dresden with more than 400 works. Nolde receives an honorary doctorate from the University of Kiel. In 1929 he moves from Berlin's Tauentzienstrasse to Bayernallee. He spends the summer and early autumn of 1930 on Sylt, where he paints and works on the first volume of his autobiography, *My Life* (*Das eigene Leben*), which is published in 1931. In that same year he is admitted into the Prussian Academy of Arts. In 1932 he is represented with seven paintings in the exhibition *Newer German Art* (*Neuere deutsche Kunst*), in Oslo, Cologne, and other cities—the last exhibition of modern German art for many years.

38　Ada and Emil Nolde with their Great Dane Fajo in front of the fisherman's house on Alsen, 1913

39　Ada Nolde during the South Sea trip on Manus, Admiralty Islands, April 1914

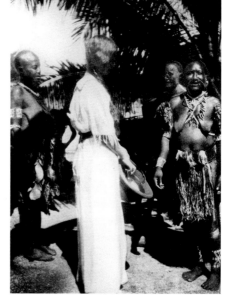

40　Utenwarf, ca. 1920

1933–1937 Attacks by the National Socialists on the avant-garde and individual artists fail to spare Nolde. He refuses to resign from the Academy of Arts. In 1934 he publishes the second volume of his autobiography, *Years of Struggles (Jahre der Kämpfe)*. As a Danish citizen, Nolde becomes a member of the NSDAP-N, founded in North Schleswig in 1935. In Hamburg he undergoes an operation for stomach cancer. In 1937 a total of 1,052 Nolde works are confiscated from German museums, and 29 of his paintings are included in the exhibition *Degenerate Art (Entartete Kunst)*. Nolde declines to emigrate to Switzerland or Denmark.

1938–1945 Visits Paul Klee in Bern. Exhibitions in Copenhagen, Odense, London, New York, and Chicago include works by Nolde. In 1941 he is expelled from the 'Reich Chamber of the Visual Arts' and forbidden to paint. Though closely watched by the Gestapo, at Seebüll he secretly paints more than 1,300 small-format watercolours, his *Unpainted Pictures*. In 1944 Nolde's Berlin atelier is destroyed by a bomb, meaning the loss of a number of works by artist friends and his own graphics collection. In 1945 paintings in storage in Teupitz are destroyed by fire.

1946–1955 Final testamentary provision for the 'Stiftung Seebüll Ada und Emil Nolde.' Ada Nolde dies on November 2, 1946. On February 22, 1948, Nolde marries 26-year-old Jolanthe Erdmann, the daughter of his friend the pianist and composer Eduard Erdmann. Nolde receives numerous honours: he is awarded the title 'professor', the graphics prize at the XXVth Venice Biennale, and the order *Pour le Mérite*. After 1945 Nolde still manages to paint more than 100 paintings, many of them after the watercolours of the *Unpainted Pictures*. In 1952 he breaks his arm in a fall in the garden, and until 1955 paints only watercolours.

1956 Nolde dies at Seebüll on April 13. The 'Stiftung Seebüll Ada and Emil Nolde' takes over his estate.

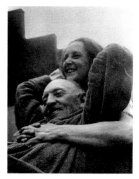

41 Ada and Emil Nolde, ca. 1936

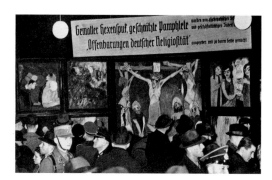

42 Emil Nolde's *The Life of Christ* in the
exhibition *Degenerate Art*, Berlin 1938

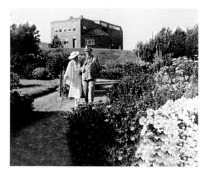

43 Ada and Emil Nolde
in the garden at Seebüll, 1941

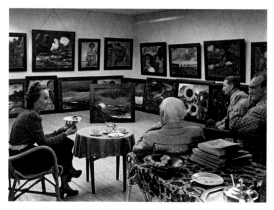

44 Jolanthe and Emil Nolde
with Karl Hagens and
Joachim von Lepel in the
Picture Hall, Seebüll, 1948

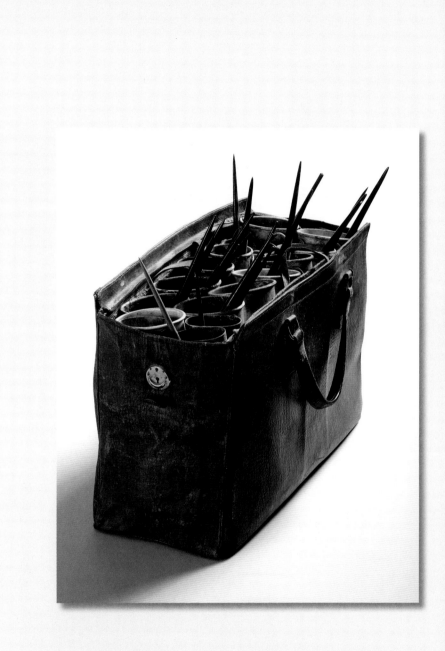

Nolde's painting satchel

ARCHIVE

Artifacts, Letters, Documents
1908–1946

On February 4, 1906, Karl Schmidt (-Rottluff) wrote to Emil Nolde "most sincerly and in homage," on behalf of the artists' group Die Brücke: *"To get right to the point – the artists' group here, 'Die Brücke,' would consider it a great honour to be able to welcome you as a member." Happily surprised, Nolde accepted the invitation: "I was not alone! There were other young, forward-looking painters with interests like mine." But his common cause with the artists Ernst Ludwig Kirchner, Erich Heckel, Max Pechstein, and Karl Schmidt-Rottluff lasted only a little over a year. In 1907 Nolde withdrew from the group. In his memoirs he writes: "It was difficult for me to bear the perhaps unavoidable frictions, personal and artistic, and I did not like the increasing uniformity of the young artists, whose works were often virtually interchangably similar. … In my heart, however, I continued to be devoted to them and was their friend in artistic matters." In 1908 Emil Nolde joined the Berlin Secession. In a letter from February 24, 1908, to Karl Schmidt-Rottluff, with whom he remained in frequent correspondence after his withdrawal from* Die Brücke, *he quoted the president of the Berlin Secession, Max Liebermann, "We don't like all of us after all." It was not only relations between the members that were strained. A battle over Nolde's painting* Pentecost *ultimately led in 1910 to his expulsion from the association and the founding of the New Secession.*

2

"In any case … I am of the opinion that my pictures of primitive people and many of my watercolours are so frank and strong that they could never be hung in perfumed salons."

"The past months have been exhilarated thanks to the invitation to take part in an expedition to the South Seas. A burning desire turned out to be fulfilled: a journey through Russia, Siberia, China, Japan, down to the South Seas. My life has been filled with excitement, and I would especially love to make the trip. And what should I be doing here, where I was despised. I've been freed from all that." In the second volume of his autobiography, Years of Struggles, *Nolde describes his delight in the planned 'Medicinal-Demographic German–*

I Letter from Emil Nolde to Karl Schmidt-Rottluff dated February 24,
1908, Archiv Hermann Gerlinger

2a

New Guinea Expedition,' in which he participated with his wife Ada from October 3, 1913, to September 7, 1914. In the fourth volume, World and Home, *he comes back to it once again: "We spent our time making preparations. We went to Berlin. We rode trained horses in the Tiergarten and learned to shoot with revolvers and rifles." He was disappointed that his friend Hans Fehr could not go along, for "a narrow-minded faculty felt it could not allow him this 'escapade.'" Fehr had been appointed an attorney at the University of Halle in 1912, and his superiors felt he was indispensable. In a letter Nolde wrote to Hans Fehr on the return trip, just before arriving in "Java, this hot dreamland," he describes his impressions of the past months.*

Steamer "Manila", May 24, 1914

My dear friend!

We're on our homeward journey. We were here in the protectorate a full six months. An eventful time, moving and exciting because of all that we saw, but also suggestive of tragedy. … The natives are a splendid people to the extent that they have not been corrupted through contact with the culture of the white men. Only a few times did we have an opportunity to get to know utterly primitive people in their villages. But how beautiful that was. Splendid figures with masses of hair, and ears and necks laden with heavy jewellery. Their houses constructed of bamboo, roofed with palm fronds,

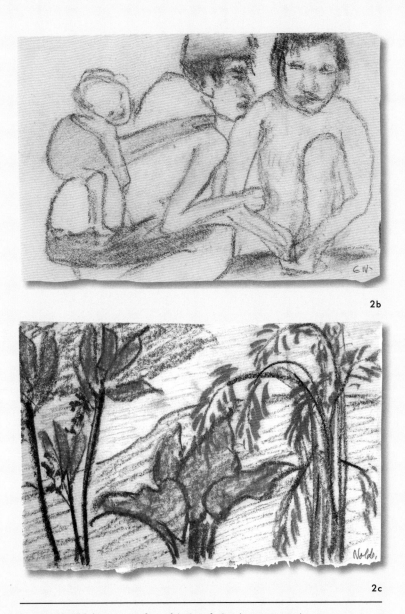

2b

2c

2a Emil Nolde's crayons from his South Sea journey 1913/14
2b *Man, Woman, and Child*, crayon drawing, 1914 and
2c *Tropical Plants (Red Blooms)*, crayon drawing, 1914,
both Nolde Stiftung Seebüll

and painted on the outside. Their canoes covered with carvings, their weapons likewise, and every utensil ornamented in the most beautiful way, painted, and carved out of solid wood. … When the ship glides across the water, heaving only slightly, one lies stretched out on a chaise, eyes closed, and the many images of what has been experienced pass in review. Would that I could hang on to some of them forever! I didn't write you much about what I accomplished, but I was very industrious, the portfolio down below is full, and I also painted some things. But with our constant travelling that wasn't so easy, and also I find that the drier air at home is more conducive to working on larger pieces. The landscape here is beautiful, but only where the Europeans have not yet carved out plantations, in these there are row after row of palm trees by the thousands. The character of the landscape is generally rugged, the forest green in green. In the bush and in villages there are lots of colourful plants, but only few flowers. There are swarms of birds, and they are magnificent, also lots of fish, they too in all colours and with splendid ornamental markings. There are no predatory beasts here and only a few snakes. The daytime hours are bright, the air moist, and morning and evening full of colours and radiance. …

Affectionate greetings from both of us, Your Emil Nolde

3

"But then I drew two letters, A and E, with a small pool between them like a jewel, connecting the letters. No one recognised these paths lined with flower beds for what they actually were. We didn't tell anyone." To this day the Seebüll garden that Nolde designed—like the house itself—is an enchanting and magical spot, where one feels particularly close to the painter and his work. Filled with colour and preserved in its original form, the garden is also testament to the deep affection between Nolde and his wife Ada, who served him as muse, model, and advisor.

The two met for the first time in the fishing village of Hundestedt, on the Isefjord, in the early summer of 1901. The young, attractive pastor's daughter and budding actress Ada Vilstrup was accompanied by her close friend, the later polar explorer Knud Rasmussen. "Afterwards they sat in the arbour drinking coffee. I stood leaning against a post, talking with the young man.

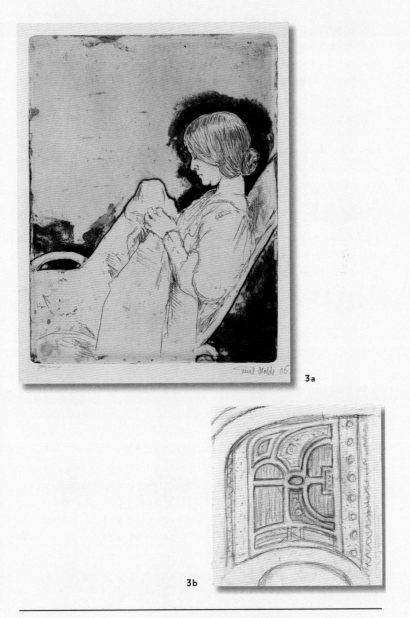

3a

3b

3a *Young Woman, Ada Nolde,* 1905, etching, Nolde Stiftung Seebüll
3b Ground plan of the garden at Seebüll designed by Emil Nolde, with
the initials A and E, ca. 1927, pencil, Nolde Stiftung Seebüll

The girl kept looking at me, the semi-debauched loner who could find words only with difficulty." It was like love at first sight; the couple married in February 1902. In his memoirs Nolde writes: "A one-eyed pastor performed the marriage ceremony. Only a few people were surprised that of all people we two wanted to be together; but we did, and that is how it was."

Ada is described as an imposing and charming, at the same time self-confident woman with energy and assertiveness. The young painters of Die Brücke *loved and admired her. August Macke's widow, Elisabeth Erdmann-Macke, describes Ada after their first meeting in 1928 as "a delicate, very personable Danish woman," but added that she later exhibited "a certain arrogance, superiority," and "she exuded a certain coolness that made one hold back." Yet the same woman also wrote critically about Maria Marc, the widow of Franz Marc, with whom she was a friend for many years.*

When Ada died in 1946 Nolde was grief-stricken: "It is as though along with my beloved companion all joy in life has vanished. ... Even though I did not paint her often, like myself, her keen mind and her character live with me in all my pictures."

4

In August 1941 Emil Nolde was expelled owing to "insufficient reliability" from the 'Reich Chamber of the Visual Arts' by its president Adolf Ziegler, and forbidden "effective immediately," from engaging in "all professional— even avocational—activity in the realm of the visual arts." Nolde described his reaction: "When this ban on painting and selling my work arrived I was in the middle of the most beautiful, promising painting. The brushes slipped from my hands. An artist's nerves are fragile, he is shy and sensitive by nature. I suffered in spirit, for I felt that my most mature works were yet to be painted. With this dark cloud hanging over me, I was robbed of movement and freedom."

Only a few of his friends knew that in a "secretive, out-of-the-way corner" at Seebüll he went on to produce a series of more than a thousand pictures, most of them small-format watercolours and gouaches that Nolde himself referred to as his Unpainted Pictures. *On July 8, 1943, he wrote on one of the many small pieces of notepaper comprising his* Worte am Rande, *or* Marginal

Notes, *which accompany his work on the* Unpainted Pictures *like diary entries and include other reflections as well, that "No one incapable of dreaming and seeing can come along."*

On one of the sheets of the Worte am Rande, *pictured here, later erroneously dated to February 6, 1940, Nolde wrote about his artist colleague Paul Klee: "The friend, the younger one, died. I, the older one, am still alive. During the months since his death my thoughts have automatically turned to him again and again. … His pictures were small, wonderfully bizarre, and infused with a playful sensitivity."*

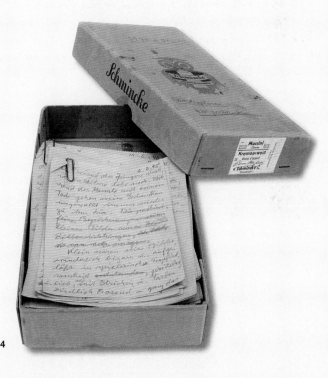

4

4 Box containing Nolde's *Worte am Rande* from 1940 to 1942, on top a note on the death of his painter friend Paul Klee, Nolde Stiftung Seebüll

SOURCES

PHOTO CREDITS

All illustration materials were graciously placed
at our disposal by the Stiftung Seebüll Ada und
Emil Nolde (photos: Fotowerkstatt Elke Walford,
Hamburg, and Dirk Dunkelberg, Berlin),
with the exception of
No. 26 (Simonsen Buchdruckerei e. K.,
owned by Julius Simonsen, Lensahn)
No. 27, private collection (photo:
Christian Dootz, Braunschweig)
No. 28, Städtische Galerie Wolfsburg
(photo: Christian Dootz, Braunschweig)
Page 63, Archiv Hermann Gerlinger

TEXT EXCERPTS HAVE BEEN DRAWN
FROM THE FOLLOWING PUBLICATIONS

The quotes in the Archive (pp. 61 ff.) come from
Emil Nolde's four-volume autobiography
(Cologne 2002) and other sources cited below.
The four volumes are cited in Roman numerals.
The quoted letters, when not otherwise
referenced, are in the archive of the Nolde
Stiftung Seebüll.
II, 99; Emil Nolde to Karl Schmidt-Rottluff in a
letter dated February 24, 1908, Archiv Hermann
Gerlinger, III, 88, II, 267; III, 13; II, 267; Hans
Fehr, *Emil Nolde. Ein Buch der Freundschaft*,
Cologne 1957, pp. 85–89; IV, 94 f.; I, 228 f.; I, 246;
Elisabeth Erdmann-Macke, *Begegnungen*, Bonn
2009, pp. 266, 285; IV, 178 f.; IV, 125; IV, 147.
Emil Noldes autobiography in four volumes:
Das eigene Leben (1867–1902), Berlin 1931,
2nd extended ed. Flensburg 1949; 8th ed.
Cologne 2002;
Jahre der Kämpfe (1902–1914), Berlin 1934,
2nd ed. reworked by Nolde himself, Flensburg
1958, 7th ed. Cologne 2002;
Welt und Heimat (1913–1918), Cologne 1965,
4th ed. Cologne 2002;
Reisen – Ächtung – Befreiung (1919–1946),
Cologne 1967, 6th ed. Cologne 2002.

Hirmer Verlag GmbH
Nymphenburger Straße 84
80636 München
Germany
www.hirmerpublisher.com

Cover: detail from *Large Poppies (Red, Red, Red)*, 1942, oil on canvas, Nolde Stiftung Seebüll
Pages 2/3: detail from *Candle Dancers*, 1912, oil on canvas, Nolde Stiftung Seebüll
Pages 4/5: detail from *Flower Garden (Marigolds)*, 1919, oil on canvas, Nolde Stiftung Seebüll

—
TRANSLATION
Russell Stockman, Quechee, Vermont

—
COPY-EDITING
Vanessa Magson-Mann, So to Speak,
English Language Services, Icking

—
GRAPHIC DESIGN AND PRODUCTION
Marion Blomeyer, Rainald Schwarz,
München and Weil

—
PRE-PRESS AND REPRO
Reproline mediateam GmbH, München

—
PRINTING AND BINDING
Passavia Druckservice GmbH & Co. KG, Passau

Bibliographic information published by the
Deutsche Nationalbibliothek. The Deutsche
Nationalbibliothek lists this publication in
the Deutsche Nationalbibliografie; detailed
bibliographic data is available on the Internet
at http://dnb.d-nb.de.

2. Edition 2016
ISBN 978-37774-2774-4

Printed in Germany